成為下一個
設計師
Becoming Designers

設計實務流程解析
Practical Procedures

目錄 / Contents

媒介連結雙方，完成了相互溝通的藝術。
不是生命的主角，卻是缺一不可的零件。

Medium has linked between the two sides,
completing the art of mutual communication.
It plays an indispensable part in life even though it is not protagonist.

視覺設計 / Visual Design

包裝設計 / Packaging Design

插畫設計 / Illustration

序
Preface

Class of 2012
Department of Visual Design
National Kaohsiung Normal University

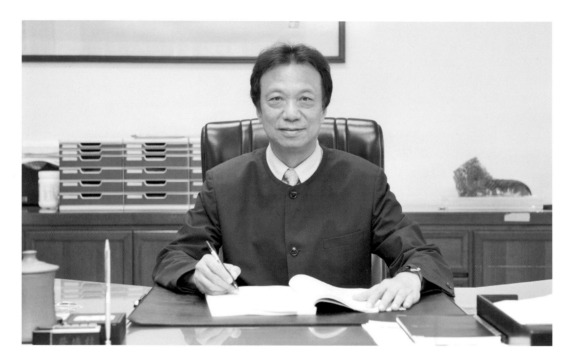

校長序 / Preface

文化創意是生活美學，文化內涵的表現，亦是國家形象與社會生命力的展現。

本校視覺設計系自成立以來，教師學養俱豐，教學運用視覺藝術相關專業來結合當代科技，成功塑造出新的文化創意價值。系上同學在校期間之設計表現傑出，屢獲國內外設計競賽佳績，使本校成為台灣南部視覺設計教育指標學府。

本校第三屆視覺設計系畢業生深具優秀設計潛力，透過專題製作Be為主體呈現四年所學成果，展出包含視覺設計、包裝設計、插畫繪本及影音動畫、創意商品等，作品表現豐富多元精彩，在此祝福本校視覺設計系畢業生未來將勇於嘗試與挑戰突破自我，發揮所學貢獻社會。

高雄師範大學 校長　蔡培村

院長序 / Prologue

國立高雄師範大學視覺設計系大學部創立於2006年,為順應時代教育潮流,以獨特性和創造性來培養學子,奠定系上具人文特色之風格,至今教學與研究質量均優。學生們於該領域表現傑出,在國內外的競賽中獲獎無數,已成南部相關系所的指標。

本屆畢業生組數眾多,所展現的作品內容十分豐富,其中包括影音動畫、平面設計、包裝設計、插畫繪本及創意商品等,各個作品爭奇鬥豔並獨具特色!此次畢業成果展,邀請各界先進教授給與指正,學子們展出的作品將是充滿創意且令人驚艷的好作品。在此祝福本校視覺設計系畢業生未來勇於接受挑戰與突破自我,在設計的領域當中發光發熱。

高雄師範大學藝術學院 院長

主任序 / Foreword

畢業製作為檢驗四年來的學習成果，通過此過程者即代表學有所成，可以畢業了。藉此機會，
向各位同學恭喜您們可以順利通過此階段，邁向人生的另一個階段－就業、深造、結婚…，此
階段將依個人的生活環境、家庭狀況、性向喜好等條件產生差異。

本系自第一屆畢業展開始，皆設定此展覽有校內的國內展及校外的國際展兩場次，今年國際展
的聯絡事務都是畢業製作的主指導老師林維俞助理教授負責執行，本年度展覽場地選定為韓國
姊妹校之東國大學的慶州分校。

這群學生經由四年的學習訓練，已經由生澀的設計嚮往者轉化成優秀的設計創意精英，此次他
們將展現集結四年以上功力所成就的設計成果，同學們的作品涵蓋了海報設計、插畫等平面
式，以及立體式的包裝、公仔等作品，內容多元豐富且具創意。希望藉此跨國際的展演機會可
以行銷自己的設計思維與技能，進而建構堅定的設計專業知能。

在此，除了勉勵同學應該持續保持著對設計的赤子之心，也期待各界先進不吝指教。

高雄師範大學視覺設計系 系主任

導師序 / Prelude

設計的進程從原創設計到任務設計或是服務設計，又回到了原創設計，今年你們這群青年設計師見證了這個更替的時刻，一年來的專題製作無疑的將創意推展到了新的境界，無論是同學們的設計成果展現，或是生命中對於「經營」與「延續」的經驗值，相信都大幅度的增加不少，再多的學習課程還是要親身的歷練才能完整填補；對於設計的熱愛與渴望，現實的殘酷與甜美，接下來就要請各位去親自品嘗了，我說，有幸陪著各位走了四年來的最後一里路，感謝。

高雄師範大學視覺設計系 助理教授

畢業製作是設計系學生破繭而出成為一位設計師之前，必須面對的考驗，除了測試自己解決問題能力和實踐團隊合作精神，也是四年學習成果的驗收和進入職場的最佳試金石。

恭喜同學們此刻都能如願達成階段性任務，透過四年累積的學習成果，在畢業專題中呈現各式各樣的多元價值與設計風貌。不論成果是否滿意，都算是負責任的給自己一個交代。希望同學們以後在設計業界或是在學界更上一層樓，要能持續畢業製作這段過程中的熱血與工作態度。

高雄師範大學視覺設計系 助理教授

洪明宏 教授
Ming-Hung Hung
Professor

廖坤鴻 助理教授
Kun-Hung Liao
Assistant Professor

李億勳 教授
Yi-Hsun Lee
Professor

吳仁評 助理教授
Ren-Ping Wu
Assistant Professor

姚村雄 教授
Tsun-Hsiung Yao
Professor

蔡頌德 助理教授
Song-De Tsai
Assistant Professor

陳立民 教授
Li-Min Chen
Professor

林維俞 助理教授
Wei-Yu Lin
Assistant Professor

張栢烟 教授
Professor

蔣曉梅 講師
Lecturer

李瑩怡 講師
Lecturer

吳淑明 教授
Professor

許惠蜜 講師
Lecturer

嚴巧如 講師
Lecturer

陳孝銘 教授
Professor

羅維嵌 講師
Lecturer

陳政昌 講師
Lecturer

黃俊綸 副教授
Associate Professor

孫祖玉 講師
Lecturer

陳立心 講師
Lecturer

洪儷庭 講師
Lecturer

陳鴻彬 講師
Lecturer

郭文昌 講師
Lecturer

洪世杰 講師
Lecturer

蔡達源 講師
Lecturer

陳雪妮 講師
Lecturer

張簡辰惠 行政人員
Staff

簡史

台灣加入WTO後，正朝國際化邁進，妥善運用視覺藝術相關專業來結合當代科技成就，以塑造新的文化創意價值，並提升國家整體的環境形象。因應這種趨勢，在校長戴嘉南博士大力支持下，由張明寮教授籌備，於民國2002年八月正式成立，張栢烟教授擔任首任所長，成立之初，即積極建立制度與發展空間、設備為重要所務。並於2004年成立碩士在職專班，提供中南部設計業界與教師進修機會，2006年成立視覺設計系大學部，招收優秀設計學生，由李億勳教授擔任首任系主任。2007年系所合一，視傳所改為視覺設計系碩士班，成立至今，教學與研究質量均優，學生設計表現傑出，屢獲國內外設計競賽佳績，在現任校長蔡培村博士推動下本系得以成為台灣南部視覺設計教學之指標。

History

After joining WTO, Taiwan has proceeded one step forwards to the trend of globalization. Thus, it is essential to create new cultural values by utilizing visual design related professions and technology to enhance the exposure of Taiwan on the global stage. In order to achieve the objectives, in August, 2002, the Graduate School of the Visual Design was founded by the supports of Principal, Dr. Dai, Jia-nan, along with the preliminary preparation devoted by Prof. Chang, Ming-liao. Prof. Chang, Bo-yan was assigned as dean of the Graduate School, who initiated to establish and develop the space and equipment for this institute. In 2004, the Graduate School of the Extended Education was established to offer continuing education for teachers and professionals in the design fields. Later in 2006, the Department of Visual Design was originated by Prof. Lee, Yi-hsuan who recruited more students with interests in design to pursuit further studies in this subject. Then in 2007, the graduate and undergraduate programs were integrated into one institute; the graduate program was re-named as the Master Program of Visual Design. Even since the founding of our programs, we have been recognized as an institute with outstanding research and teaching quality. Our students have constantly received numerous prizes at home and abroad for the quality of their works. With the achievements, we have been known as the leading figure in the visual design education in southern Taiwan.

教學及研究特色

本系碩士班乃因應我國南部地區缺乏視覺傳達設計高層研究人力而籌設，基於實際情況考量，宜成立涵蓋理論及創作並重的研究場域，以消弭理論與實務間的差距；本系大學部，針對前述成立背景及設計理由而創立，一來源於肩負提升視覺設計人力的藝術素質，解決當今偏重專業技術培育導向而失衡的設計人力，二來著實本著以藝術為本位文化為內涵，以培育藝術與科技素養兼備的人才，為發展之軸心與依循。另一方面，本系設置於藝術學院，旨在著重藝術品味與美感素養，並以人文科學之精神與哲學論證的學理，來強化高級設計教育的本質。

Characteristic

Due to the lack of advanced researches in Visual Design in southern Taiwan, this Graduate School of Visual Design was therefore established to bridge the gap between theory and practice. Soon after, the Undergraduate School was founded to enhance the artistic level of those in visual design, in attempt to adjust the imbalanced human resources caused by the bias of professional-skill-oriented demands; to equip the students with arts knowledge and technical skills by arts and culture. Moreover, this Department, located in the College of Arts, aims to develop one's artistic taste and aesthetic knowledge by the humanistic spirit and theory to achieve higher essence of design education.

教學及研究重點

1. 課程、設備與空間的規劃強調實務、開放、多元的特點。
2. 以啟發引導方式鼓勵學生思考和想像，發揮設計。
3. 結合尖端科技與數位媒體，尋求設計的嶄新風格與方向。
4. 培育具藝術品味與視覺設計的理論研究及創作兼備人才。

Mission

1. To reinforce the planning of curriculum, equipment and space to be more pragmatic, open, and diverse.
2. To inspire and encourage student's critical thinking and imagination in the process of creativity in design.
3. To incorporate advanced technology and digital media for new styles and directions in design.
4. To equip the students with the knowledge of design theory and creative thinking.

發展方向與主旨

新方向的探索：
以視覺設計與藝術的基礎課程為核心，發展學生以文化藝術為設計的基礎理念。

新技法的整合：
以藝術創作與科技媒體的雙軌學習為導向，鼓勵學生多元實驗技法與創新風格。

推行產學合作：
積極加強與業界合作交流，落實學生設計工作參與經驗，以提升設計實務能力。

Development and Aims

A new exploration:
Based on culture and arts, to help students develop their fundamental concept in design with the core courses in visual design and arts.

A new skill:
To encourage students to experiment with new skills and styles through artistic creations and new media from the latest technology.

A promotion of university-industry collaboration:
To reinforce the cooperation between university and industry in order to have students gain more practical experiences and design skills.

未來展望

1. 積極與國內外設計學校與業界交流，建立資源共享關係。
2. 規劃成立博士班，期使本系達到設計學程系統之完整化。
3. 舉辦國際學術活動交流及設計展演，建構系之主體研究。

Visions

1. Involving more channels of communication with design related institutes at home and abroad to share resources.
2. Planning the establishment of doctoral program to achieve the completeness of the design curriculum system.
3. Hosting international conferences and design exhibitions to construct our foundation of research in design.

視覺設計
Visual Design

Class of 2012
Department of Visual Design
National Kaohsiung Normal University

張鈞堯 / Chun-Yao Chang

flickr.com/photos/aron676
goodluck676@hotmail.com

只要持續前進，
有天就能到達夢想中的天地。

Life takes effort.
Keep moving forward.
One day you can define your destiny.

● 視覺設計 Visual Design ● 個人 Individual

視覺設計
/ Moving Forward

Q：專題介紹

A： 想表達一個簡單的概念：勇往直前。
故事中小人物在汪洋大海中找尋傳說中浮在海面的陸地。過程中雖然遭遇到幾次的威脅與困難，但他沒被打敗，繼續朝目標前進。強調人生應該要勇於追求夢想，主要想提醒年輕人們不要畏懼挑戰，儘管過程中可能不順遂，但應該勇敢堅持走出自己的路。

Q：製作此作品用的軟體是什麼，它如何將你的設計發揮到極致？

A： 此短動畫我使用Autodesk Maya軟體，這個功能強大的3D軟體我想大家都不陌生。它的功能很齊全，讓我無論是從建模、貼圖、打光到動態以及最後的算圖都能在裡面完成。同時它優異的算圖器讓畫面更真實、更美觀。拜現在優異的科技軟體所賜，只要把故事設定好，它都能幫我實現。

Q：請談談你如何克服創作上遇到的瓶頸，也給對設計有興趣的讀者們一些建議？

A： 對我來說最困難的時刻總是在開始做之前，娛樂以及雜事容易使人分心，但保持著一開始那股熱誠及行動力可以幫助我進入狀況。在製作上，需要面對自己技術不夠成熟導致需要更多時間摸索、嘗試，來補滿基礎不紮實的漏洞。提醒各位有興趣製作動畫的同學提早做事前準備還是比較好的。

Q：在設計中，觀者的感受與自我的重要性，哪方面為重？

A： 我覺得設計必須要考慮到觀者的感受。一個成功的設計工作者必須擁有獨特想法但同時必須想辦法使自己的作品與觀者產生共鳴。

Visual Design
/ Moving Forward

Q：Project introduction.

A：The main idea of the animation is simply telling people to keep the faith and try your best to chase the goal. In the story, the character is searching for the land in fable that is floating in the sky. Though there are dangers and challenges in the process, he does not give up. There I put the concept in my final project, reminding me to keep moving forward and also trying to encourage all the young people to conquer the challenges and always try their best in doing everything.

Q：Which software did you use in this project? How did it help you bring out the best of your design?

A：In this animation, the software I used is Autodesk Maya which is a 3D animation software delivering an end-to-end creative workflow. It has with comprehensive tools for animation, modeling, simulation and some cool visual effects. Especially, it has a fine rendering engine that did me a big favor on the animation quality. Thanks to the progress of technology, I can do so many things once the story is set.

Q：Please tell us how you overcame the difficulties during the project and give some suggestions to the readers who are interested in design.

A：As far as I am concerned, the hardest part of doing the project is to defeat all the temptations and get it started. After struggling with so many entertainments around, my activeness pulls me back into work mode. During the production, I find software operating cost me much time on testing due to the fact that I do not have concrete foundation in the domain. So I strongly recommend those who want to make an animation, to start as soon as possible.

Q：When it comes to design, between designers and appreciations whose feeling is more important?

A：A good designer has to not only possess his own specific viewpoints about the design but also arouse the viewers' sympathy with his works.

MOVING
FORWARD

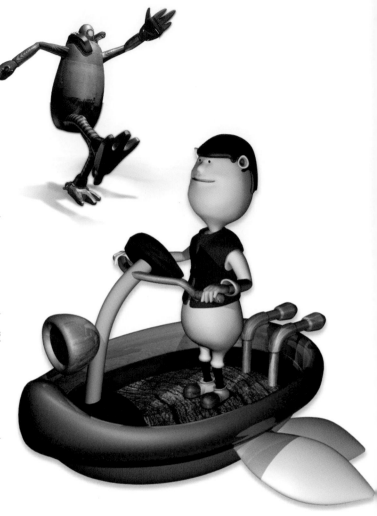

製作流程
/ Procedure

點子 / Idea

人人都有夢想，它正在前方等待我們去追。

If you have dream, just go for it. Eventually, the dream will come true.

劇本 / Script

以追夢為出發點，小人物在經歷種種困難後繼續朝夢幻島前進。

The story talks about pursuing dream. After suffering from some frustrations, the character keeps moving forward.

分鏡 / Story Board

預設動畫總時間，將故事分為三部分繪製分鏡圖。

Set the film time. Start drawing story board. Then separate it into three parts so you can control time easier.

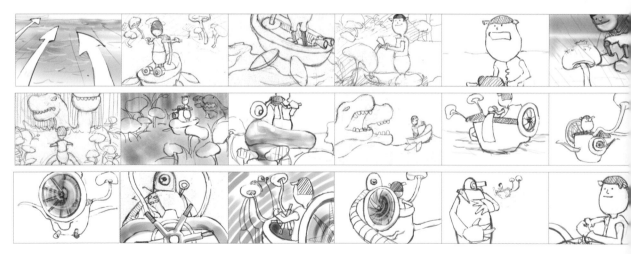

● 視覺設計 Visual Design　　● 製作過程 Production Process

軟體操作
/ Software Operation

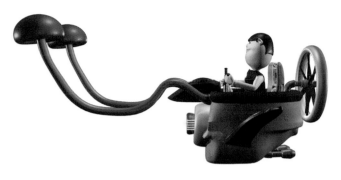

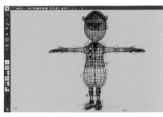

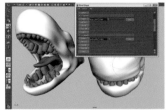

建模：設定故事需要的角色與場景草圖進入3D軟體建立立體化模型。
材質：選擇合適的的材質球並在材質網路連結作編輯處理。
骨架：為使角色能自由動作，必須為它製作骨架並適當調整權重。
動態：根據動態腳本時間設定腳色動作與攝影機的運動。
算圖：分層算圖以方便後製個別圖層的調整。

Model: Set the characters and scenes that the story need. Draw the sketches of them. And then use 3D software to create 3D models.
Texture: Use Surface Material and edit it in HyperGraph. Good texture can make object seem more real.
Rigging: Create joints for the character and adjust weight so you can make it move. And you can use Blendshape to create facial expression.
Animation: Make animation according to the motion story board and set camera movement to make the shot you want.
Render: Render layers for edit use.

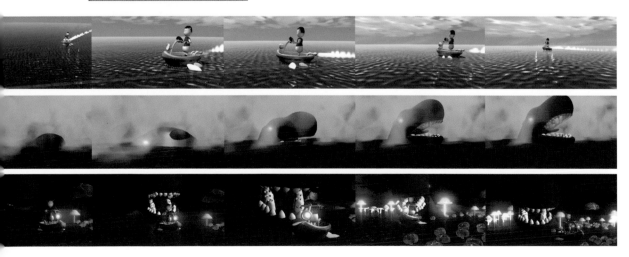

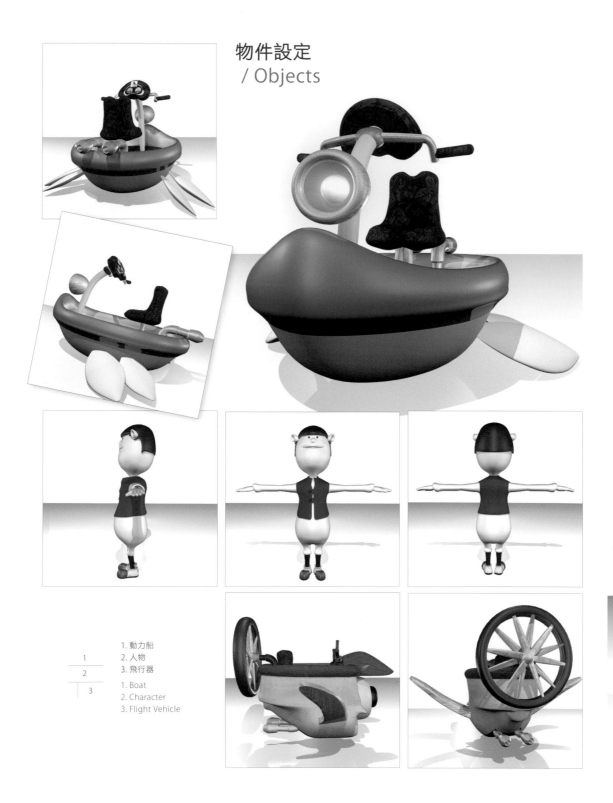

物件設定
/ Objects

1. 動力船
2. 人物
3. 飛行器

1. Boat
2. Character
3. Flight Vehicle

1
2
3

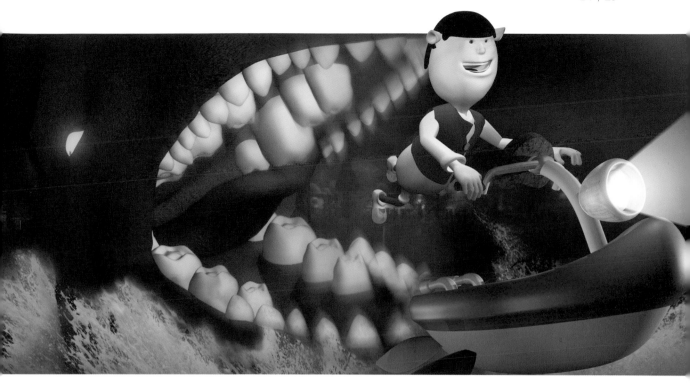

概念發想
/ Concept

常常在追尋夢想之前，可能有無數的疑問暫時無解，
於是開始懷疑自己是否有能力、方法是否正確、能否
持之以恆的努力下去或是別人會怎麼想。這一次讓我
們很單純的鼓起勇氣，放手去做。

雙十年華的我們對於長大後必須獨自面對的世界既是
好奇興奮又是恐懼畏縮。猶豫的同時，大環境已一步
步逼迫你我走出當初的舒適圈。面對外在接踵而來的
挑戰，我們只有勇往直前！

Before pursuing the dreams, there are still many
questions remaining unsolved to you. No matter
how capable you are, how correct the way is, how
long you can keep going or what others think of
you, this time, just be brave and do it.
When we were young, the curiosity and cowardice
lived within us. As we were still confused about
the future, the time had forced us to move on.
Let's get rid of our past, all we need now is
transformation. Life is an adventure. Define your
destiny.

劇情
/ Story

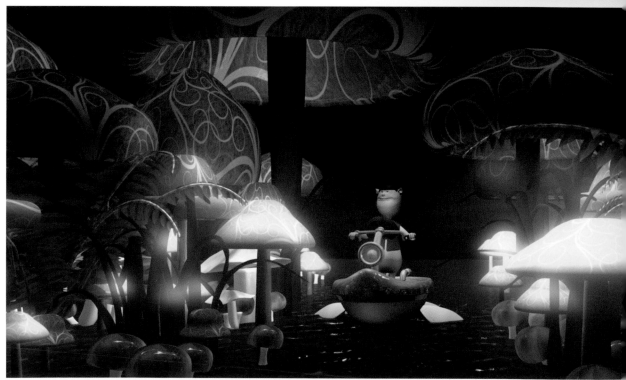

這一天小人物出發尋找夢幻島。汪洋大海中，他駕駛小船從白天行駛至黑夜，來到一個美麗的螢光蘑菇森林。驚喜的同時，在前方濃濃雲霧中出現了形似島嶼的影子，於是他滿懷期待地上前去。沒想到竟然是隻大海怪正張開血盆大口朝他襲來。

在小人物乘上飛機飛向天際後，他繼續尋找夢幻島。這次他誤以為一個巨型機器人是他要找的目標，攻擊性機器人也沒有讓他輕易度過這難關。在一次次的挫敗後，終於，眼前的出現了美麗的夢幻島。

This day, the character starts to search for the Dream Island. In this endless ocean, he rows the boat from day to night. Then he comes to a beautiful forest which is full of fluorescent mushrooms. Being surprised, he also finds that there is a shadow seeming to be an island in the foggy clouds. So he comes closer with curiosity. Astonishingly, it is a dangerous monster that is so angry and wants to kill him.

Taking the plane and flying away into the sky, he keeps looking for the Dream Island. This time he misunderstands that the big giant robot is his goal and this aggressive robot does not let him pull through the difficulties easily. After being frustrated over and over again, finally, there is the beautiful Dream Island coming into his eyes.

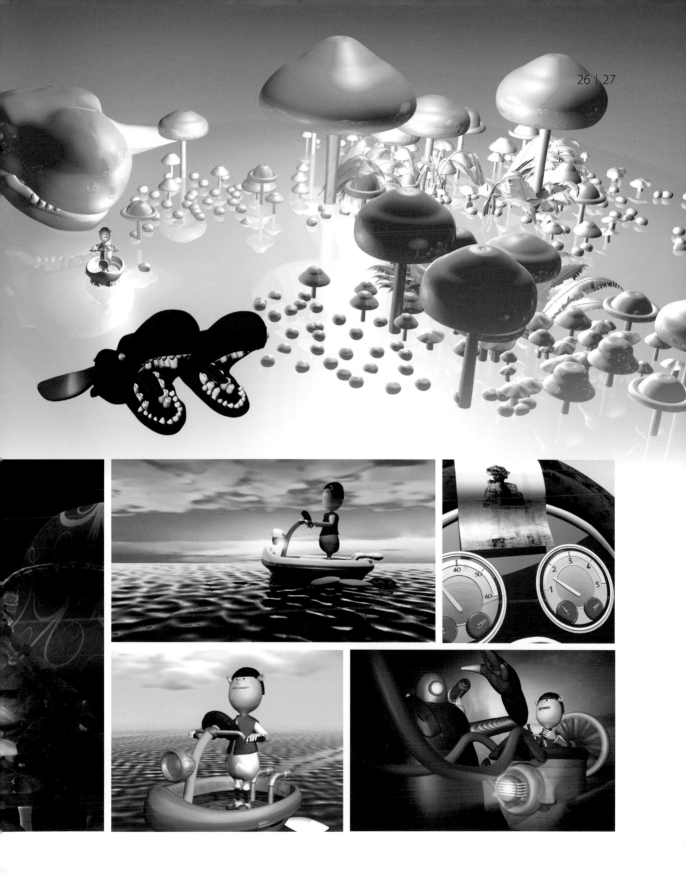

設計作品 Design Works　　●　　視覺設計 Visual Design　　●

徐桂雄 / Guey-Seong Chee

flickr.com/photos/cheemala
b3ar814@hotmail.com

英文是世界國際語言，由26個字母所組成。
我想讓孩子更容易記憶這26個字母元素。

English is an international language, composed of 26 letters.
By different ways, I wish to help the children pick up the alphabet more easily.

● 視覺設計 Visual Design ● 個人 Individual

視覺設計
/字母行

Q：專題介紹

A：每個孩子在學習英文的最初階段都會先接觸英文單字，對於什麼樣的形式可以讓孩子更容易吸收，這就取決於字卡呈現方式。我所製作的作品主要是想創造出同樣事物中不一樣的一面，讓觀者認為其實它也可以這樣做！

Q：製作此作品用的軟體是什麼，它如何將你的設計發揮到極致？

A：此作品主要使用的軟體是Adobe Illustrator CS5，因為這個軟體可以讓我隨意的使用幾何形狀來變換各種物體，加上可以隨時更換色彩，以達到最理想的配色。

Q：請談談你如何克服創作上遇到的瓶頸，也給對設計有興趣的讀者們一些建議？

A：在設計的過程中，設計者往往會碰上　些釘子，東西如果太過雜亂整理不了的話，建議你去洗個熱水澡，把頭泡在蓮蓬頭下靜靜的整理思緒，有時候反而還會有其他不一樣的想法出來！就像腰帶綁太緊了無法呼吸，一旦解開呼吸也就順暢了！

Q：請舉例最喜歡的雜誌或書籍編排，介紹一下吧？

A：我最喜歡的雜誌是IdN以及dpi。IdN雜誌主要以設計工作者角度為讀者報導台、港、新、印、美、澳等地設計作品與最新動態；而dpi主要以插畫，每一個作品都有其特別的性格，喜歡塗鴉的朋友其實可以多觀摩觀摩！

Visual Design
/ Alphabet

Q : Project introduction.

A : Children learn the alphabet in the first stage of learning English. The alphabet cards create a new learning style. My project aims to create the different aspect of a same thing, letting the viewers realize there is another way of doing it.

Q : Which software did you use in this project? How did it help you bring out the best of your design?

A : The software mainly used in my project was Adobe Illustrator CS5. It allowed me to change the geometric patterns and the colors by myself to achieve the desired goal.

Q : Please tell us how you overcame the difficulties during the project and give some suggestions to the readers who are interested in design.

A : Designers always encounter obstacles during the process. I suggest you to take a shower when you meet some problems in your design. When you relax, you might think of some different ideas! You cannot breathe if the belt is too tight; you have to loosen it up.

Q : Please introduce your favorite layout style of magazines or books.

A : My favorite magazines are IdN (International designers Network) and dpi (design popular imagination). IdN is a magazine for the designers, reporting the news in Taiwan, Hong Kong, Singapore and America, etc. Dpi is an illustration magazine; every project in it has a different style.

目的
/ Purpose

為了能讓小朋友更容易吸收單字及單詞，運用了字母以及迷宮的結合，讓孩子藉由遊戲與父母互動從而更容易記憶單詞。

In order to help the children learn the alphabet and vocabulary more easily, the alphabet is combined with maze. Through the game and interaction with parents, the children could memorize the alphabet easily.

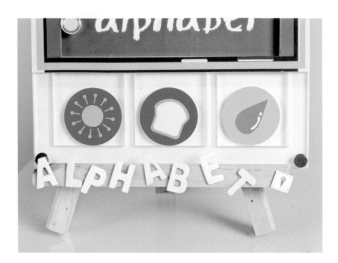

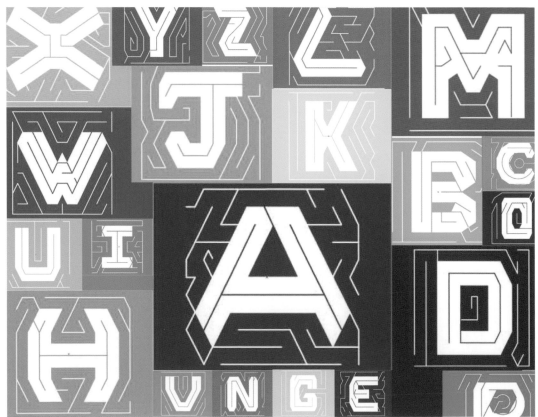

● 視覺設計 Visual Design　　● 製作過程 Production Process

概念發想
/ Concept

教育孩子必須要從小開始，也就是從我們生活周遭開始尋找可以讓孩子學習的目標。只要是能夠讓孩子看得到的物品，我們都可以一一拿來當作教材使用。生活中的孩子就像是處在一個諾大的迷宮中，每天都往不同的方向前進、每天碰到不同的新鮮事物，以此作為發想將元素與迷宮結合呈現一套不一樣的教具！

Education should start from the child stage, which can be achieved by utilizing the materials in our daily life. Anything that children see could be the teaching materials. To kids, the real life is like an enormous maze: going toward different directions everyday; encountering with different new things. That is why the elements and maze are combined to present a brand new set of teaching material.

概念流程 / Conceptual Progress

以英文字母A的三角形體為藍本重新繪製26個英文字母。孩子的思維模式較為單純，迷宮路線不可過於複雜，以防止孩子太容易就失去興趣。使用對比強烈、鮮豔的顏色能夠讓孩子更容易辨識及記憶，而且也容易吸引他們的注意力。在迷宮當中放入對應的學習素材，也能加強孩子對事物的認知能力。

Taking the triangular font of English alphabet "A" as the original version to draw 26 English letters. Children's thinking is simple. The maze's route cannot be too complicated in order to prevent the children from losing interest. Use a strong and colorful contrast to help children increase their recognition and memory. Thus, integrating the teaching materials into the maze is the best way to reinforce children's cognition.

標誌 / Logo

取自於ALPHABET的第一個字母，同時也是26個英文字母的首位。字母A分別由九個幾何三角（分別代表9條迷宮線條）組成，再由線條勾勒出字母A的形體，意味著有入口就一定會有出口的意思，活潑的顏色也象徵著孩子們的活力、歡樂、純真。

Taken from the first letter in the alphabet, also the first letter of the word "alphabet." "A" is assembled by 9 maze routes. Using the outline to draw the font of the letter. It signifies that if there is an entrance, there will be an exit. The bright colors symbolize children with full energy, joy and innocence.

印章 / Stamps

9種不同形態的線條印章為製作本次迷宮的基本元素，可以製作屬於你自己的迷宮城堡，也可以製作不同於別人的字母。再來還有英文字母以及小素材印章以提升小朋友與父母之間的互動關係。

Nine different kinds of line stamps as the basic elements to create the mazes. Not only can you make your own maze kingdom, but can create one-of-a-kind letters. In addition, the alphabet and stamps can increase the interaction of the children and their parents.

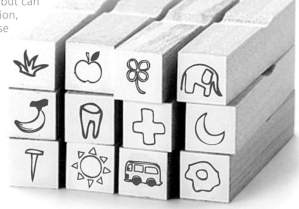

色彩計劃 / Color Plan

以CMYK印刷色作為基準色彩進行延伸搭配，結合歡樂、活力，創造繽紛活潑的感覺。

Use CMYK as the color plan to extend. Combine entertainment with energy to create the good sense of liveliness.

APPLE	BEE	ELEPHANT	HANGER	ICE-CREAM
VAN	LOVE	HOSPITAL	CLOVER	NAIL
SUN	JET	BANANA	GRASS	ORANGE
BALLOON	CAT	MOON	EGG	WATER
FIRE	RIBBON	KEY	DESK	QUEEN CROWN
PENCIL	YOLK	MUSIC	TOOTH	ZOO
X-RAY	TREE	UMBRELLA		

1. 收納罐
2. 小物件
3. 收納罐與小物件

1. Storage Box
2. Small Items
3. Storage Box and Small Items

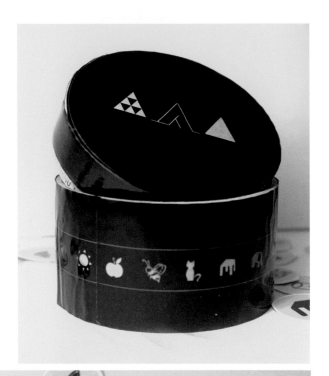

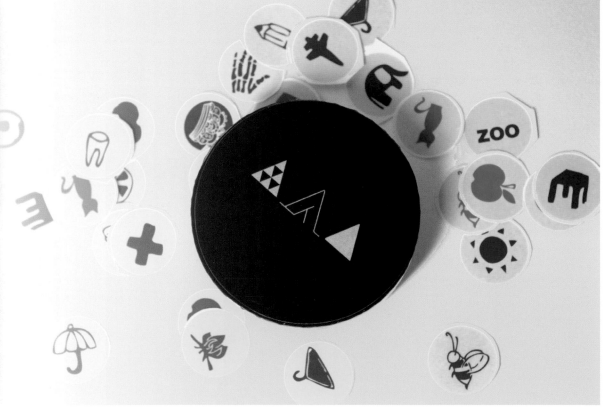

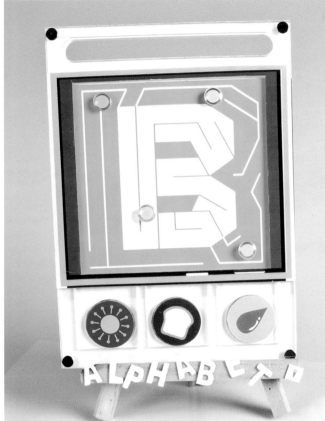

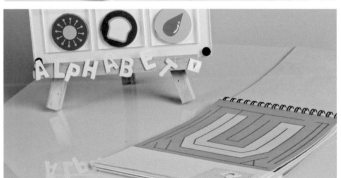

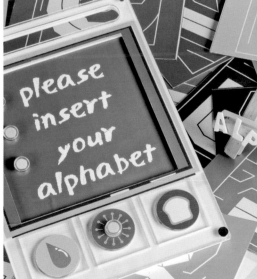

設計作品 Design Works　　　視覺設計 Visual Design

呂佳懋 / Chia-Mao Lu

flickr.com/photos/joefantasy
fantasy750215@hotmail.com

Core
of
Heart

如果代表一個人的是他的「心」
那代表一個人的「心」的又是什麼？

If "heart" represents a man,
then what represents the "heart"?

● 視覺設計 Visual Design ● 個人 Individual

視覺設計
/ Core of Heart

Q：專題介紹

A：「情緒」在普遍認知上，是種抽象而主觀的東西，同樣一件事，對於不同的人都可能造成完全不同的影響。有一部分的人，因為生理上的失常造成個人無法控制的情緒失常，須面對他人所無法理解的精神折磨，卻仍得承受社會上不包容的責難，而這全是因為情緒的主觀性造成的，這點激發了我的思考，讓人想嘗試看看，能否以客觀的方式，藉由影像的媒介來傳遞「情緒」的變化。

Q：製作此作品用的軟體是什麼，它如何將你的設計發揮到極致？

A：建模使用Autodesk Maya，利用Adobe Photoshop CS5繪製貼圖，再配合Adobe After Effect CS5進行畫面動態的營造以及後製效果。

Q：請談談你如何克服創作上遇到的瓶頸，也給對設計有興趣的讀者們一些建議？

A：平時很愛看電影，在於情感的表達部分，有相當多的電影做的很棒，從中可以學到很多東西；而國外很多遊戲在動畫方面其實也做得相當出色，對於動畫有興趣的人可以多方涉獵，不一定要只看書籍來學東西。

Q：在動畫裡的各種造型有著非常特殊的風格，請問你是如何構思的？

A：從個人的經驗中建立一個基礎，再綜合他人對情緒的描述來強化其視覺性，並整理出較具代表性的形象。也參考了一些講述色彩學和共感覺的書籍，讓那些視覺形象能夠更客觀。

Visual Design
/ Core of Heart

Q：Project introduction.

A：In common sense, emotion is abstract and subjective. The same thing could cause different effects on different people. Due to the abnormal physical condition, some people suffer from their own minds, and yet the society still blames them for their malfunction. It is all because the subjectivism of emotion. It makes me wonder if I can express emotion via the combination of specific and objective images.

Q：Which software did you use in this project? How did it help you bring out the best of your design?

A：Autodesk Maya for modeling, Adobe Photoshop CS5 for drawing textures, and Adobe After Effect CS5 for making it dynamic and for post production.

Q：Please tell us how you overcame the difficulties during the project and give some suggestions to the readers who are interested in design.

A：I watch a lot of movies. Many motion graphics use excellent ways to express emotions. Some video games also have great trailers. Communication comes in multiple ways. You can learn a lot from many things. It does not have to come from books only.

Q：The characters In the animation has a very unique figure; how did you create it?

A：I concluded other people's description about their feelings, and amplified it based on my own experiences. I also used some theories about chromatology and synesthesia, trying to create the more objective images.

標誌 / Logo

直接以主題名稱字體設計，字體上的漸層代表著影片中不斷變動的
意涵，另以一擴散的黑圓代表劇情中的負面意義。

The logo is composed of the project's title. The blends on those
letters represent the variations, and the extending black dot
symbolizes negativity.

角色設定 / Character Design

動畫主軸偏抽象、沒有對話和明顯的劇情，主角也傾向於只是個表
現和接受情緒的個體，因此沒有一個固定清楚的形體，而是會持續
改變的，然而主角主要代表的是負面情感，因此身上會有一些象徵
性的黑色空洞，整體色調也偏晦暗，而第二主角是以女性的型態呈
現，代表著正向的情感，因此設定上的色彩偏暖色系。

The animation has neither conversation nor evident storyline.
Characters merely become a medium of expressing emotions,
so they do not have a stationary shape. However, the main
character stands for negative emotion. Therefore it tends to have
cold tone colors, while the second character indicates positive
events and has warm and cheerful colors.

以下圖片則是主角的基本造型。

The following pictures are the basic modeling of two characters.

場景1 / Scene 1

主角的房間，影片一開始的場景，呈現灰白和半透明色調，在主角醒來後，整個場景的空間會不斷擴大、產生沙的質感，從時鐘的轉動可看出時間的流動變得緩慢了，象徵空虛和孤獨的情緒。

First scene in this animation is the main character's room, displaying with gray scale tone and translucent objects. After he wakes up, the room will start expanding and will appear a sand-like texture, meaning emptiness and loneliness. You can also find the time flowing slower on the clock.

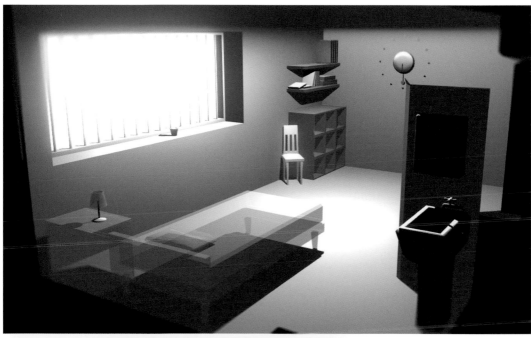

設計作品 Design Works ● 視覺設計 Visual Design ●

用城市來表現焦慮和些微憤怒的情感，以紅藍等對比色調拼湊出衝突感，所有色塊和線條都會快速移動，而人群抽象化成一塊塊不會交集的平面，傳達現今社會所常見的快步調生活以及人與人之間的疏離感。

In metropolis scene, rapidly moving lines and red/blue blocks piece up the feeling of conflict and anxiety. The people on the street become non-crossing planes to convey the alienations in today's fast-paced life style.

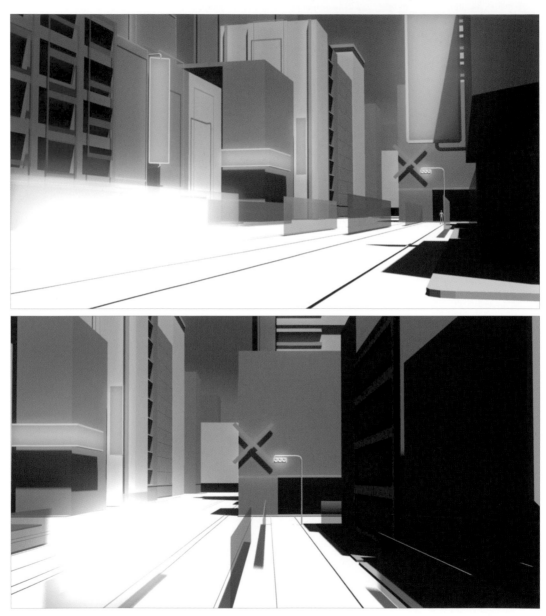

場景3 / Scene 3

地下道場景，主角在此想逃避城市的喧囂，短暫的平靜卻使他得面對從內心散發的黑暗，用扭曲的線條和陰暗的色調來傳達混亂和質疑。

The main character enters, trying to escape from the bustle and hustle of the city. But the temporary silence leaves him no choice but to face his own darkness. The underpass scene uses distorted lines and gloomy color to express chaos and doubts.

包裝設計
Packaging Design

Class of 2012
Department of Visual Design
National Kaohsiung Normal University

張德美 / De-Mei Zhang

flickr.com/photos/zohom
honeyspine4@yahoo.com.tw

即使試圖詮釋自然的可愛之處，
但當我散步在天空之下，才發現永遠説不完。

Even if I have tried to describe the loveliness of nature,
I still find myself always talking on and on every time I walk beneath the sky.

● 包裝設計 Packaging Design　　● 個人 Individual

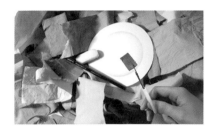

包裝設計
/ seasons 外帶餐具

Q：專題介紹

A：這次專題，期待能為忙碌的外帶族—上班族提供愉悅的用餐經驗，seasons以四季自然的美好營造舒適情緒，敬祝用餐愉快！

Q：製作此作品用的軟體是什麼，它如何將你的設計發揮到極致？

A：最棒的軟體是萬能的雙手，她創造難以取代的手作感，最終以Adobe Photoshop CS5作細節如：陰影與色彩的修飾。

Q：請談談你如何克服創作上遇到的瓶頸，也給對設計有興趣的讀者們一些建議？

A：多聽聽他人的想法，接著聽聽自己的內心，然後，繼續想破頭吧。

Q：請問你設計包裝時，有什麼樣的考量？想運用設計傳達什麼理念？

A：從使用者的使用習慣考量，從前有些人習慣將每天的日曆紙用來墊便當，因此將富季節主題的餐墊製作成季曆（因為並不一定每天都吃便當），方便上班族使用，即使忙碌中也可以彷彿在自然中野餐，不使用時，只掛著可知曉當季花草們。這件設計，有鼓勵人親近自然，並以愉快心情用餐的涵義。

Q：你有欣賞的設計師或藝術家嗎？他們對你的影響為何？

A：藝術家奈良美智以及設計師森本千繪。
奈良先生呼喚在我心底孩童的雙眼，提醒我很重要的好奇心；森本小姐自然中展現纖細的設計令人十分欣賞，在欣賞他人的作品時可補充伊我進一步的能量。

Packaging Design
/ seasons

Q : Project introduction.

A : I want to provide cheerful experience of dining for the busy office workers. seasons uses natural beauty of four seasons to create a comfortable atmosphere.
Bon Appétit!

Q : Which software did you use in this project? How did it help you bring out the best of your design?

A : The best tool is the hands, the texture by hands is irreplaceable. The details were done by Adobe Photoshop CS5, such as the modification of shadows and colors.

Q : Please tell us how you overcame the difficulties during the project and give some suggestions to the readers who are interested in design.

A : Listen to the ideas of others and listen to your inner thought. Then, think harder!

Q : What's your consideration when designing the product? What concept do you want to convey?

A : I took users' habits into consideration. Some people use daily calendar piece as the lunch mat; therefore, I reversed the idea, creating the quarterly calendar from dining mat with the theme of 4 seasons. (It is quarterly because we do not necessarily eat lunch every single day). The product is easy for the office workers to use; they could dine in the nature-like atmosphere even in their busy life. In addition, it can be used as the calendar if it's not used as the dining mat. The design encourages us to get closer to the nature and to have a pleasant mood while having meals.

Q : Do you have any favorite artist/designer? How does he/her influence you?

A : Artist Yoshitomo Nara & designer Morimoto Chie. Mr. Nara arouses my child-like instinct, reminding me that "Never forget your curiosity." Ms. Morimoto's slim design style in nature is very impressive. I could absorb different ideas while appreciating others' works.

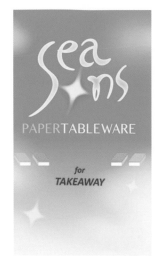

名片 / Business Card

概念發想
/ Development of Ideas

散步時低頭看看，有很多想像不到的美麗圖案，因此試著思索與時俱進的線索：
季節、日曆、野餐
「用餐時能簡單擁有野餐般的好心情就好了！」
就是這次專題的由來。

Looking down on the ground when taking a walk, you will see a lot of beautiful patterns. Therefore, the clues of time came up: seasons, calendar and picnic.
"It will be great if we can have meal with the good mood as in picnicking."
This is the concept of the theme.

製作過程
/ Production Process

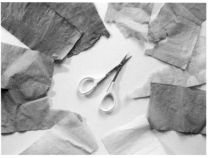

1. 水彩、水性色鉛筆、染色的餐巾紙。

Watercolor, water-based color pencils, and stained paper napkins.

● 包裝設計 Packaging Design　　● 製作過程 Production Process

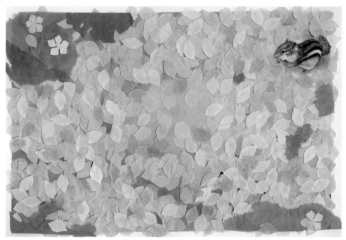

2. 選用餐巾紙的原因：方便均勻染色，紋路自然，剪裁或撕裂都有不錯的效果。適合做大量重複的大面積背景。用水彩輔助整體的配色，小型精緻物件則以色鉛筆描繪。

The reasons of using napkins: Unify staining and natural patterns. The cut or tear has a good effect and is suitable for repeating a large area of background. Watercolor supports the overall colors. Delicate objects are painted by color pencils.

3. 掃描入Photoshop修飾瑕疵，用筆刷工具畫出陰影，畫面變得有立體感了。接著，放入方便用軟體製作的幾何物件與文字。

Scan into Adobe Photoshop CS4 for modifying defects, using BRUSH tools to draw a shadow. Then, place in geometric objects and text which is made in the software.

4. 將一張張季節更迭的日曆紙餐墊，用木條麻繩裝幀一起，就完成了一季的日曆。

Bind the calendar papers. Place mat with strips of wooden rope to finish the seasonal calendar.

系列實品
/ Series of Real Products

吐司盒 / Toast Box

吐司裝吐司。
Toast is put in the toast box.

seasons日曆 / seasons Calendar

無論天氣好不好，用日曆野餐吧！
Whether the weather is good or not, use the calendar for picnic !

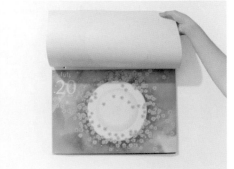

夏季日曆 / Summer Calendar

夏天開始了。
含苞待放的金毛菊，吸引嗅到花朵氣息的尖粉蝶而來。

It is summer time. The budding golden chrysanthemums attract butterflies with their fragrance.

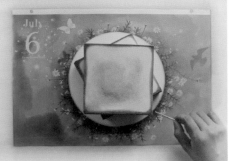

● 包裝設計 Packaging Design　● 設計作品 Design Works

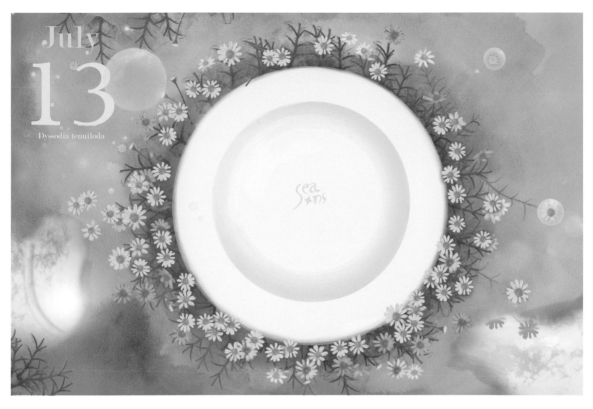

金毛菊隨著夏日花越開越多，熱烈午後雷陣雨在地上留下幾圈積水，倒映出雨後天晴的彩虹。

Golden chrysanthemums bloom in the summer. The warm afternoon thunderstorms leave the ground a few puddles, reflecting the clear rainbow after the rain.

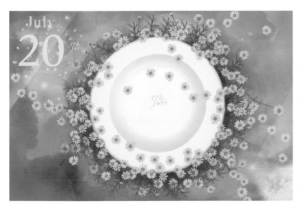

越加盛開蔓延的花，繞出圖形。

Increasingly, the blooming flowers circle and create a pattern.

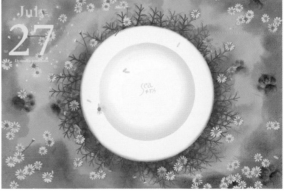

後來卻被好奇的小狗踩亂了。

End up being trampled by the curious dog.

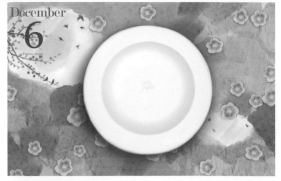

十二月。鳥群在梅樹樹梢飛舞，地面有零散掉落的梅花，水窪映出冬日的灰白天空。

December. Birds fly around the plum trees. The plum blossoms scatter on the ground.
Puddles reflect the gray skies of winter.

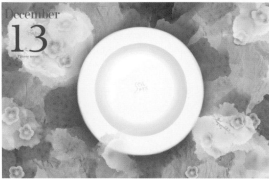

時序進入深冬，地面開始結霜，短草皮逐漸改變了顏色，少了鳥群的蹤跡。

It is the winter time, the ground begins to frost.
Short turf gradually changes the color.
The traces of the birds in the sky are gone.

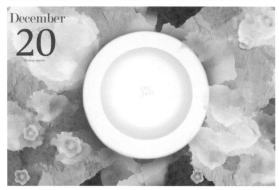

霜越結越多，地面被凍得露出了表土。

As the increasing of frostings, the ground is frozen and exposes the topsoil.

當初掉落地面的梅花，已被凍在霜裡，大量的霜白令人感覺到冬寒的美麗。

The fallen plum blossoms have been frozen in the frostings. The enormous frosts give the beauty of the chilling winter.

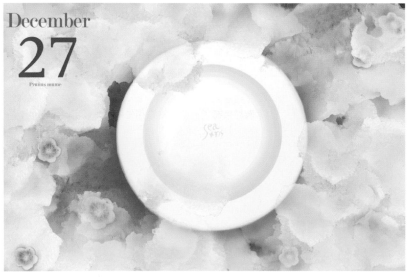

● 包裝設計 Packaging Design　　● 設計作品 Design Works

春季日曆 / Spring Calendar

三月。當季的粉櫻花開始鋪起粉色地毯，以及共襄盛舉的白色日日春，讓春天的綠意顯得特別鮮嫩。

March. The season of cherry blossoms begins to scatter the pink carpet and join the festivities of white periwinkles. The greenness seems particularly fresh.

櫻花持續飛落，逐漸蓋住綠地，置身花雨的動態感中。

Sakura keep falling down and covering the grass slowly. The scenery is exposed in the dynamic sense of flower rain.

隔壁的山櫻樹也開花了，為餐盤裡貢獻了不少漂亮花紋。

The cherry trees in nearby mountain also bloom, and contribute a lot of beautiful patterns to the plate.

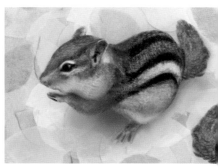

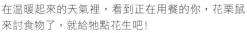

在溫暖起來的天氣裡，看到正在用餐的你，花栗鼠來討食物了，就給牠點花生吧！

The weather warms up. Chipmunks come to ask for food, just give it some peanuts !

鍾馨誼 / Shin-Yi Chung
flickr.com/photos/anversive
aejean0224@hotmail.com.tw

張勝崴 / Sheng-Wei Chang
flickr.com/photos/mummjonjon
mummyjonjon@hotmail.com

謝　雅 / Ya Hsieh
flickr.com/photos/44748208@N02
celia0602@kimo.com

FEAST
赴宴專業外燴

「辦桌」是台灣重要文化之一，以台灣傳統特色
與現代元素結合，規畫出新的視覺形象。
賦予喜宴另一種視覺享受。

The feast is an important culture of Taiwanese.
Our purpose is improving the visual image of the feast and combining
the Taiwanese traditional characteristics to present the generation of art.

● 包裝設計 Packaging Design　　● 團隊　Team

包裝設計
／赴宴

Q：專題介紹

A：赴宴—給你最尊榮的視覺享受。

以象徵富貴與吉祥的牡丹花為主，運用漸層的手法讓牡丹擁有新的視覺樣貌，並加入傳統圖樣等元素重新組合，搭配燙金文字讓整體質感提升。我們將主色調以紅色印象呈現，使中國風的氛圍更加濃厚，給人懷舊又嶄新的視覺，讓所有來參加筵席的賓客，除了有味覺方面的享受，更能夠品味台灣喜宴文化的特色與內涵。我們將喜宴的視覺品牌化，從整體形象到包裝設計，做出完整系列的規畫。

Q：製作此作品用的軟體是什麼，它如何將你們的設計發揮到極致？

A：我們主要以Adobe Illustrator CS5矢量的特色繪出主視覺與排版設計；以Adobe Dreamweaver CS5、Adobe Flash Catalyst CS5編輯動態網頁，而網頁視覺則是由Adobe Fireworks CS5、Adobe Photoshop CS5、Adobe Illustrator CS5、Adobe Flash CS5等軟體交互使用；在影片製作上，使用Adobe After Effect CS5及Adobe Premiere CS5為主要製作工具。

Q：請談談你們如何克服創作上遇到的瓶頸，也給對設計有興趣的讀者們一些建議？

A：關於「喜宴設計」的題材，市面上已經不勝枚舉。如何將我們的主視覺設計得富有現代感又不缺少台灣味，利用思考模式的轉移以及多樣風格的嘗試與結合，設計將變得相當有趣且出色。

Q：你有欣賞的設計師或藝術家嗎？他們對你的影響為何？

A：欣賞的設計師：Rainbowmonkey，他想為每個專案都尋找獨特語言，除了充滿奇思異想的設計，他更關注細節與高標準的品質，這是非常值得學習的。

Packaging Design
/ The Feast

Q：Project introduction.

A：The feast gives you the most dignitary enjoyment. We use peony to symbolize auspiciousness and wealth. We endow it with new visual appearance with gradient colors, and combine it with traditional design. We also gild the words to give it a better quality. In addition to enhancing traditional culture of Taiwan, we use the red color to give customers the feeling of retrospect. Our purpose is to combine the traditional Taiwanese culture with our design. We turn the image of the feast into a brand, creating a complete series of designs, from the overall image to the packaging design.

Q：Which software did you use in this project? How did it help you bring out the best of your design?

A：We used Adobe Illustrator CS5 to design visual images and layout; Adobe Dreamweaver CS5 and Adobe Flash Catalyst CS5 to edit webpage; Adobe Fireworks CS5, Adobe Photoshop CS5, Adobe Illustrator CS5 and Adobe Flash CS5 to design visual images of the webpage. As for the movie making, we used Adobe After Effect CS5 and Premiere.

Q：Please tell us how you overcame the difficulties during the project and give some suggestions to the readers who are interested in design.

A：The ideas of the feast is too many to enumerate. How to modernize our main visual image, meanwhile not ignore the Taiwan traditional culture was a challenge for us. By shifting the thinking patterns and attempting to experience various styles, the designing became fascinating and outstanding.

Q：Do you have any favorite artist/designer? How does he/her influence you?

A：Rainbowmonkey is our favorite designer. He tends to seek unique language for each project. In addition to abundant bizarre designs, his attention to details and high quality is what we should look up to.

概念發展
/ Development of Ideas

喜宴是人生中特別的里程碑，更是反映個人風格與品味的饗宴。以「辦桌文化」為主要發展軸心，將傳統與現代元素結合，在此，我們邀您以獨特的風格歡慶您的大喜之日。

Feast is the special landmark in our life and it reflects individual style and savor. We use the feast culture as the core of development, combining traditional culture and modern elements. Now, we invite you to celebrate your feast day with distinctive style.

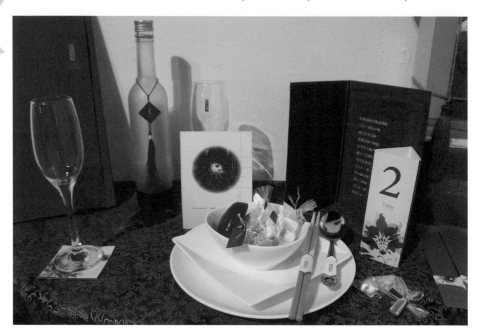

主視覺發想
/ Design Process

鳳凰有「愛情」、「夫妻」的意思，中國文學中時常比喻為「真摯的愛情」。

Phoenix symbolizes "love" and "couple" in Chinese culture. Chinese literature often uses it as the metaphor for "eternal love."

牡丹花深為中國人所喜愛，是人們喜聞樂見的花，具有「富貴」、「圓滿」之意。

Peony has always been favorable to the Chinese, and it is fancied by people with the meaning of wealth and perfection.

我們試著突破人們對牡丹造型的印象，將花瓣以漸層的形式呈現，結合現代感並賦予文化傳承的使命。

We try to break through the impression people have on peony. We present the pedals with gradient form, combining with modernity. Pass down the mission of the cultural heritage.

● 包裝設計 Packaging Design　●　製作過程 Production Process

主視覺介紹
/ Introduction

主視覺分別為牡丹及百合花兩系列，均以單一的紅色花瓣以不同透明度層疊方式呈現，帶出層次感。
左為牡丹花系列，右為百合花系列。

Our main visual design is the peony and lily series, they are single red petals showing different transparency layers.
Left: Peony series. Right: Lily series.

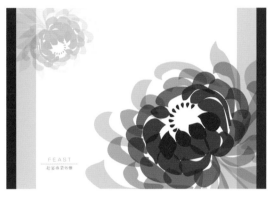
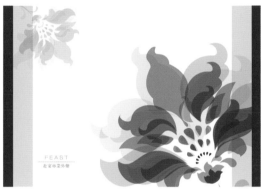

牡丹象徵圓滿；百合象徵百年好合，我們嘗試將這些祝福「視覺化」，因此將花以綻放的形式呈現，除此之外，也讓吉祥的氛圍更加濃厚，並有著獨特的藝術形式。

Peony symbolizes perfection; lily symbolizes conjugal bliss. We try to visualize these blessings. Therefore, the flowers are presented in bloom. In addition, the auspicious atmosphere is more intense and it has an unique art form.

將中國傳統的吉祥花與喜宴外燴結合，在視覺與味覺的催化下，譜出更美妙的享受。

Combine Chinese traditional auspicious flowers and wedding banquet catering. With vision and taste as the catalyst, the exquisite delight is formed.

為因應現代市場需求，赴宴外燴餐廳經我們重新定位與設計規劃，使其形象別於一般的外燴餐廳，讓它更有東方的文化特質與新的意涵。

In response to the modern market demands, we reposition and re-design for the catering restaurant. Therefore the image is different from the general catering restaurant, endowing it a more Oriental cultural characteristics and a new meaning.

品牌定位 / Brand Orientation

品牌目標為精緻高價路線，主要目標鎖定財力較為寬裕的高收入族群以及白領階層，這些客戶更注重產品的內容、品牌、服務以及文化價值。

The brand aims for sophisticated high-end market. The main targets are those well-paid populations and white-collared workers. These customers pay more attention to the content of the product, brand, service and cultural values.

標準色 / Color Plan

色彩搭配以紅、黃色調為主，配合淡雅的材質，將現代融入中國風格，加深人們對台灣的本土印象。

Red and yellow serve as the main tone, with the elegant materials. Integrate modernity into Chinese style, reinforcing people's impression on Taiwanese culture.

● M 100 / Y 100 / K 20

● M 35 / Y 85 / K 15

標誌演變 / Logo Development

我們希望在標誌中加入東方元素，以增加國人的文化情感。我們分別利用「書法風格」輔以印章圖像，與「意象」圖形表達出現代感。

We added the oriental elements to the logo, hoping to reinforce people's cultural sense. In addition, we utilized the calligraphy, with auxiliary stamp images, to combine with the "image" pattern to express the modernity.

標誌 / Logo

在Logo造型上，我們使用剪紙風格融入「中國風」，讓整體塑造新氣象，更有中國當地的特色。

We combine the paper-cut style with the "Chinese style", so that the overall shapes can convey brand-new and Chinese local characteristics.

FEAST

赴宴專業外燴

FEAST

赴宴專業外燴

海報 / Poster

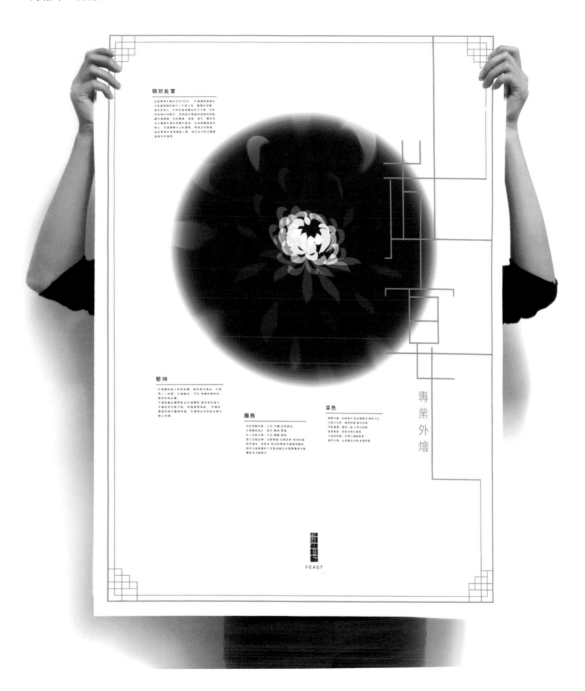

周邊商品 / Merchandise

運用赴宴的視覺形象及輔助圖案來營造整體視覺形象的中國風格及喜宴的喜悦感與祝福，透過精緻化的設計，藉以提升赴宴外燴餐廳的消費層與價值。

We use the visual image and auxiliary patterns to convey the joy and blessings of Chinese banquet. Through the exquisite design, we hope to elevate the value of the catering restaurant, bringing in more customers.

1	2
3	4

1. 識別證與酷卡系列
2. 員工制服
3. 名片與工作證設計
4. 文件封套系列

1. ID Card and Card Series
2. Staff Uniform
3. Business Card and Work Permit
4. Document Envelope Series

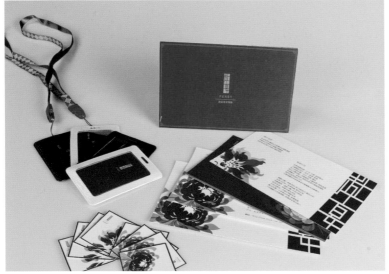

● 包裝設計 Packaging Design　　● 設計作品 Design Works

商品 / Merchandise

	1		
2	3		
	5		
4	6		

| | | | |
|---|---|---|
| 1. 員工工作服 | 1. Staff Uniforms |
| 2. 問卷調查表 | 2. Questionnaire Series |
| 3. 酷卡式DM | 3. DM Series |
| 4. 邀請卡 | 4. Invitation Cards |
| 5. 餐具系列 | 5. Tableware |
| 6. 桌牌設計 | 6. Table Plate Design |

插畫設計
Illustration

Class of 2012
Department of Visual Design
National Kaohsiung Normal University

施漢欣 / Han-Hsin Shih

flickr.com/photos/hellohs
crystal_163453@hotmail.com

張清媁 / Ching-Wei Chang

flickr.com/photos/candybelle
kurapica05@hotmail.com

回歸自然，享受純粹的趣味。

Return to nature.
Enjoy the pleasure of purity.

● 插畫設計 Illustration ● 團隊 Team

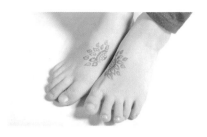

插畫設計
/ Tintoo

Q：專題介紹

A：「Tintoo」是個暫時性紋身概念。這個詞是我們從 tint+tattoo上創造出來的，意思就是用染色取代刺青。我們選用了植物染料「指甲花」當作我們的媒材，這種染料除了不傷皮膚外，更擁有豐富的傳統印度身體彩繪文化。我們以此作為延伸，設計出屬於Tintoo風格的彩繪圖案，來創造人與人之間有更多的互動。

Q：製作此作品用的軟體是什麼，它如何將你們的設計發揮到極致？

A：我們的製作分成平面跟圖形設計兩個部份：圖形的部份手繪佔了很大的比重，先再紙上做大部份的設計，才掃描進入電腦用Adobe Illustrator CS5進行簡單的修改，為的就是要保持手繪的自然樣貌。而平面的部份使用了Adobe Photoshop CS5做影像處理以及Adobe Illustrator CS5排版。

Q：請談談你們如何克服創作上遇到的瓶頸，也給對設計有興趣的讀者們一些建議？

A：瓶頸的話，應該是很難去開發出各種不同的圖案吧！每個人都會有自己喜歡的風格與樣式，那麼創作各種不同風格其實很困難。所以我們找了各式各樣的書籍，也參考了很多的圖片，才使我們圖案的樣子慢慢定型下來。

Q：請舉例最喜歡的雜誌或書籍編排，介紹一下吧？

A：數位藝術插畫的話，意念圖誌是本很棒的雜誌！它有大量的視覺圖案，有各種不同的風格的設計師提供經驗，有時候看看那些設計以外的分享，也對創作很有幫助！

Illustration
/ Tintoo

Q：Project introduction.

A："Tintoo" is an idea of temporary "tattoo." The word is made from tint+tattoo by ourselves. It means to tint the skin instead of having tattoo. We choose the harmless "Henna" as our material, which is the traditional paint of Indian body art. Referring to the body art, we design patterns of our own style to create an interaction among people.

Q：Which software did you use in this project? How did it help you bring out the best of your design?

A：The project has two parts: graphics and patterns. Most of the pattern making parts were made by hand drawing. We designed them on paper, and then scanned them into computer to build a vector graphic in Adobe Illustrator CS5. As the graphic part, we used Adobe Photoshop CS5 to do the image processing, Adobe Illustrator CS5 to compose the layout.

Q：Please tell us how you overcame the difficulties during the project and give some suggestions to the readers who are interested in design.

A：We found it hard to create different kinds of patterns. Everybody has their own style. It is difficult to include all kinds of styles by one person. So we resorted to a variety of books and pictures to help us settle the pattern designing.

Q：Please introduce your favorite layout style of magazines and books.

A：If you like the digital illustration works, The Digital Artist will be a great choice! There are so many illustration styles and the artists of all types to share their experiences. Sometimes to read the sharing is great for our creation as well!

概念發展
/ Development of Ideas

從代替刺青的概念，找到指甲花作為暫時性紋身的媒材。利用指甲花可在皮膚上染色的特性，將英文「tint」與「tattoo」結合而創了「Tintoo」一詞。以設計紋身圖樣為主，也針對品牌也做了包裝以及品牌識別設計。

With the idea of replacing tattoo, we take the Henna as the material of temporary tattoo. Using the dyeable feature of Henna, we combine the word "Tintoo" with "tint" and "tattoo." In addition to the creation of patterns, we also make packages and VI design for the brand.

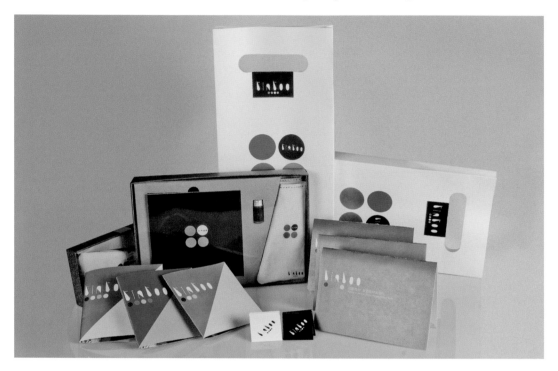

標誌修改
/ Modification of Logo

tintoo tintoo tintoo

先由手繪方式，在紙上確定造型以及大小間距。

First, create the model by hand drawing. Draw up lots of drafts, then select what we need.

掃描進電腦後，運用鋼筆工具，拉成向量線條。

Scan the graphic into the computer. Use the pen tool to make vector curves.

由於線條太過理性，於是將線條封閉填色成為色塊為主的標誌。

Due to the hardness of the curves not being able to fit for Tintoo, seal the lines and fill color in it.

● 插畫設計 Illustration　● 製作過程 Production Process

圖案發想
/ Concept of Patterns

無法刺青的族群大多是青少年（女）至兒童的年齡範圍，因此內容設計用童話故事的元素，發展出一系列個性又充滿玩心的圖樣。

Because most children and teenagers are not allowed to get tattoos, we use fairy tale's elements to create the patterns.

先由手繪方式，畫出大量的草稿，在紙上確定造型，再逐一篩檢。

Create the model by hand drawing first. We draw up lots of draft, then select what we need.

掃描進電腦，轉換成向量圖形。保留手繪線條形成的手作自然風格。

Scan into the computer to make vector graphics. But the shapes are kept in the hand-made style.

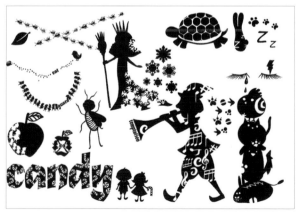

進行排列與組合賦予故事性，但每個圖案皆可分開，成為獨立的圖案。

Arrange the patterns by the sequence of storyline. But every pattern can be separated individually.

標誌 / Logo

以色塊呈現的標準字作為商品標誌，搭配圓點進行組合，排列出兩款供不同的商品使用。

Using the arrangement of font and circles as our logo.
We create two combinations for different kinds of packages.

標準色 / Color Plan

以原色的概念設計出四種顏色，並調和本身產品的調性，讓多彩的玩心裡又融入刺青的個性感。

Based on the idea of the tricolor, we create four colors as our color plan. We mix up the colors with dye image, endowing the tattoo with a colorful impression.

- ● M 30 / K 90
- ● C 25 / M 70 / Y 70
- ● C 65 / M 45 / Y 25 / K 10
- ● C 65 / M 45 / Y 65 / K 5

包裝設計 / Packaging Design

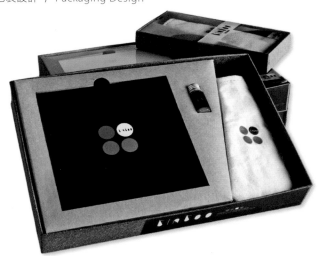

● 插畫設計 Illustration　　● 設計作品 Design Works

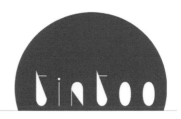

圖樣設計 / Pattern Design

結合各種類型的童話故事，利用故事元素設計出圖案，並將之組合，
也可將其分開成個別獨立的圖案。

We create the patterns and set the layout with the elements of
fairy tales. They can also be separated as individual ones.

1	2	
3	4	5
6	7	8

1. 冰雪女王
2. 花衣魔笛手
3. 不萊梅的城市樂手
4. 糖果屋
5. 白雪公主
6. 蚱蜢與螞蟻
7. 龜兔賽跑
8. 美人魚

1. The Snow Queen
2. Pied Piper of Hamelin
3. Town Musicians of Bremen
4. Hansel and Gretel
5. Snow White
6. The Grasshopper and the Ants
7. The Tortoise and the Hare
8. The Little Mermaid

設計作品 Design Works ● 插畫設計 Illustration ●

應用設計 / Applied Design

延伸主視覺的色彩，設計出各種不同獨特又活潑的用品。

Extending the color of the vision, we design several
unique and interesting applications.

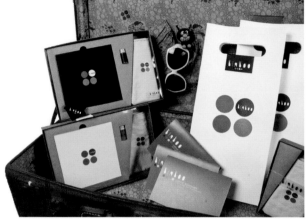

1	4
2	5
3	6

1. 應用設計展示　1. Collection Display
2. 使用說明書　　2. Instruction Manual
3. DM設計　　　3. Advertisement
4. 5. 6. 名片設計　4. 5. 6. Bussiness Cards

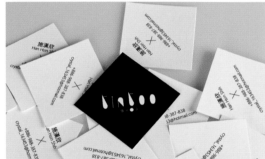

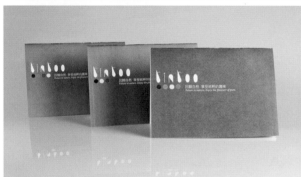

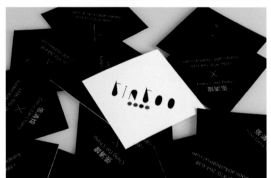

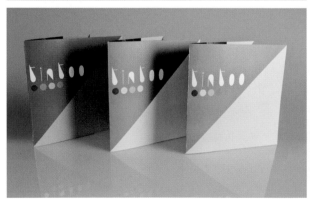

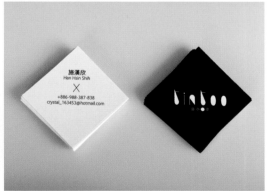

展示設計 / Exhibition Design

以照片展示人體繪畫的效果，整體以營造回歸自然為主題，選用咖啡色系的裝飾物，展現木質感及回歸無汙染年代的本質。

To display the effect on the body. To build natural appearance as our theme. Choosing decorations with the color of wood to show the essence of unpolluted life.

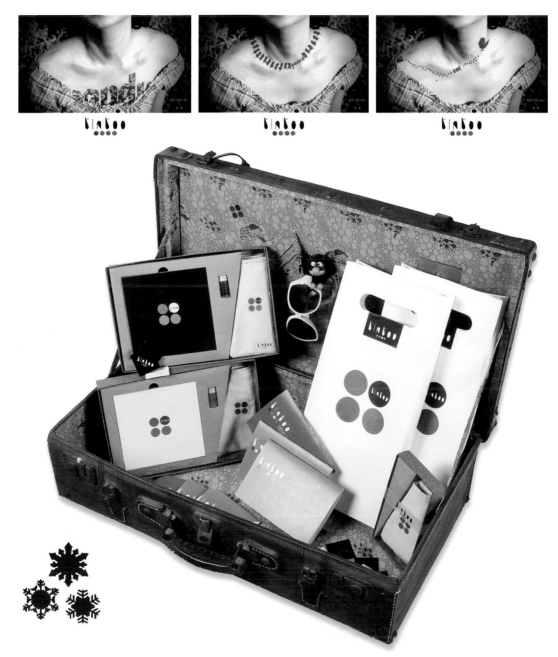

蕭智鴻 / Zhi-Hong Xiao

flickr.com/photos/47109252@N02
windinsgt@hotmail.com

TREASURE HUNTER

喜歡大家聚在一起大吵大鬧，
喜歡生活就像玩遊戲一樣有哭有笑。

I love how we get together, making the noises.
I love to live like playing games, having ups and downs.

● 插畫設計 Illustration　● 個人 Individual

插畫設計
/ 桌上遊戲

Q： 專題介紹

A： 我覺得人生最大的目的就是快樂，所以希望做能讓一款能讓大家都開心的遊戲。因此我做了一套可以讓二到四人遊玩的桌上遊戲。桌上遊戲和電腦遊戲兩者之間最大的不同點，在於桌上遊戲可以讓人面對面直接溝通往來而電腦遊戲無法。在遊戲中玩家將會在遊戲裡扮演奪寶獵人，來到一座危機四伏的城堡，在一個充滿陷阱與怪物的環境下四處探索，彼此較勁看誰能拿到最多的寶藏，就能夠得到奪寶王的稱號。

Q： 製作此作品用的軟體是什麼，它如何將你的設計發揮到極致？

A： 使用了Adobe Photoshop CS5進行繪製作業，沒有另外用鉛筆打稿再掃描到電腦上，而是從草稿到上色都在電腦上完成。而除了軟體之外，硬體的部分也十分的重要：一塊好的繪圖板是電腦繪圖必須的工具。

Q： 請談談你如何克服創作上遇到的瓶頸，也給對插畫有興趣的讀者們一些建議？

A： 在創作的過程中，有時會發生畫不出自己腦中所想的畫面的狀況。建議對插畫有興趣的讀者平時可以多嘗試揣摩各種畫風，久而久之就能夠提升自己的能力並且創造出別人都學不來的繪畫風格。

Q： 你有想過在未來從事什麼樣的工作嗎？如果有，那可能會與你的創作?有何關連？

A： 我未來想要成為一名遊戲企劃或是遊戲設計師，所以選擇了遊戲這個題目作為創作主題，希望能夠親手實際製作一款遊戲的方式，了解本身所欠缺的部分。

Illustration
/ Board Game

Q： Project introduction.

A： I think we should live for fun. So, I hope to make an interesting game for everybody. For this reason, I made a board game for 2 to 4 players. The difference between board game and computer game is that board game allows people to communicate face to face, but computer game does not. Players will act as treasure hunters in the game. This time, they come to a dangerous castle. The person who can get the most treasures is the winner to this game.

Q： Which software did you use in this project? How did it help you bring out the best of your design?

A： I only used Adobe Photoshop CS5. I did not use pencil to sketch and then scan the draft into computer. I completed my work in computer from sketch to coloring. In addition to software, hardware is also important. A good drawing tablet is required for Computer Graphics.

Q： Please tell us how you overcame the difficulties during the project and give some suggestions to the readers who are interested in design.

A： Sometimes during the process, I cannot draw out the images in my head. I would suggest the readers to try different styles of painting. As time passes, your painting ability will improve, and you will create an unique style of your own.

Q： Have you ever thought of what kind of jobs you will do in the future? If yes, will there be any relation to your creation?

A： I want to be a game project manager or a game designer in the future. For this reason, I chose this subject as my project. I am hoping to realize what I am lack of through making a game by myself.

桌遊的遊戲性
/ The Fun of Board Game

桌上遊戲不只是遊戲而是一種與人互動的模式，
因此除了畫面，在遊戲規則的設定上更為重要。
奪寶獵人這款遊戲著重在猜測對方思考的策略上。

Board game is not just a game but a mode of
interaction with the people. Therefore, besides
the display, the rule setting is more important.
The game "Treasure Hunter" focuses on
guessing other players' thinking strategies.

策略的靈活性
/ Strategies

為了增加遊戲中策略選擇的自由度，在遊戲每回合
開始時，需要配合接下來的想要進行的行動選擇行
動卡。玩家從下列五張選擇其中一張：

In order to increase the game's flexibility, at the
beginning of each round of the game, we need
to adjust the selection action cards with what
you want to do. Players will choose one from the
following five cards:

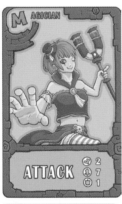 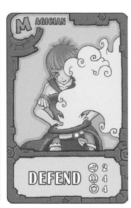 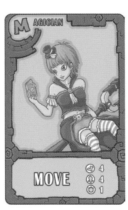 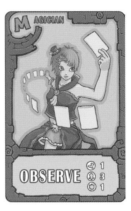

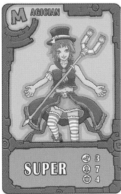

1	2	3	4
5			

1. 攻擊：當你想要攻擊怪物或玩家的時候。
2. 防禦：當你想要防禦玩家或怪物攻擊的時候。
3. 移動：當你想要快速移動到某地圖的時候。
4. 觀察：當你想要干擾其他玩家的時候。
5. 必殺：當你想要孤注一擲的時候。

1. Attack: When you want to attack monsters or players.
2. Defend: When you want to defend attack from players or monsters.
3. Move: When you want to quickly move to a map.
4. Observe: When you want to interfere with other players.
5. Super: When you want to stake your luck on a single throw.

● 插畫設計 Illustration　　● 製作過程 Production Process

玩家互動性
/ Interaction

在遊戲裡讓玩家之間可以以某種方式互相干擾並競爭，促進遊戲過程中玩家間的彼此互動。
當玩家選擇「觀察」行動後，將可以在所有玩家行動開始前，從三張埋伏卡中選擇一張，這需要玩家嘗試去猜測其他玩家接下來的行動。

Players can interfere with one another and compete in some ways to promote the mutual interaction between players during the game. When the player selects "Observe" action, he can choose an Ambush Card from the three before all players start the action. Therefore, the player needs to try to guess the next action of the other players.

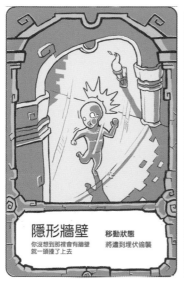 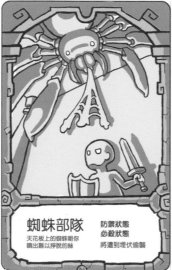 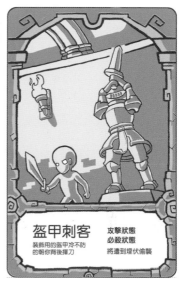

1 | 2 | 3

1. 隱形牆壁：城堡中出現埋伏，影響選擇「移動」的玩家。
2. 蜘蛛部隊：城堡中出現埋伏，影響選擇「防禦」或「必殺」的玩家。
3. 盔甲刺客：城堡中出現埋伏，影響選擇「攻擊」或「必殺」的玩家。

1. Invisible Wall: Influence the players who choose "Move."
2. Spider Army: Influence the players who choose "Defend" or "Super."
3. Armor Assassin: Influence the players who choose "Attact" or "Super."

標誌 / Logo

為了配合卡片整體的形象，以簡單的色塊和些微斑駁的裝飾線條構成。

In order to integrate with the image of cards, the logo is composed by a simple color and totemic lines.

TREASURE HUNTER

標準色 / Color Plan

之所以選用暖黃色調作為標準色，除了象徵泛黃的老舊城堡的背景外，也傳達遊戲帶給人的愉悦感。

The reason why I use warm yellow in the color plan is not only the color symbolizes the old castle's image but also it expresses the joy when we play this game.

● C 5 / M 50 / Y 75

● C 5 / K 100

包裝 / Packaging

使用紙盒包裝桌上遊戲，除了方便攜帶外，也方便在通路上販售。

Use the carton box as the packaging. It is not only easy to carry but also easy to sold in board game shops.

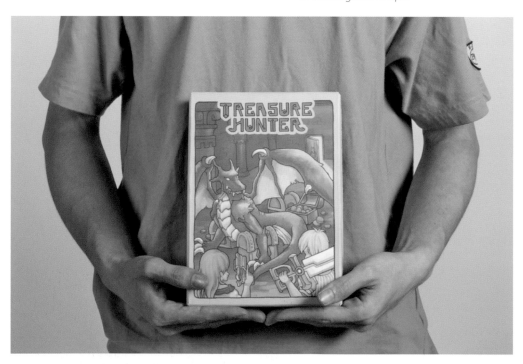

● 插畫設計 Illustration　　● 設計作品 Design Works

角色卡與怪物卡 / Character Cards and Monster Cards

使用明顯的黑框線和繽紛的塊狀顏色營造出鮮明的卡漫風格。此外為了維持不同種類卡片間的整體感，卡片外框的設計上採用同樣風格的裝飾性線條。

Use black edges and bright color blocks to create an unique style. In addition to retain the same style of different cards, the design of card frame has the decorative lines of same style.

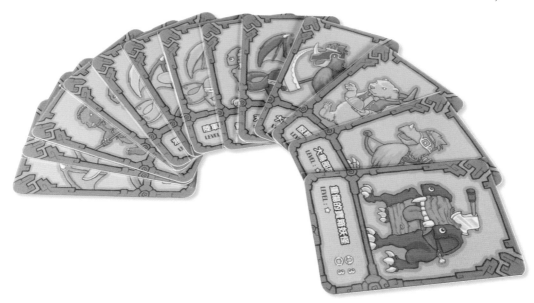

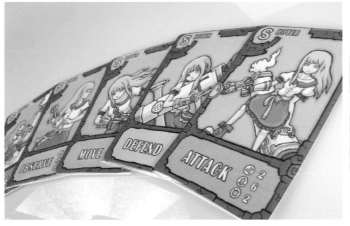

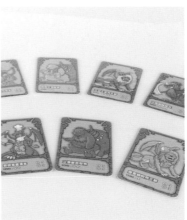

遊戲進行時的地圖並沒有固定的樣貌，而是以
隨機的方式形成地圖，這樣的好處是每次遊玩
時都能夠有不同的樂趣。
而棋子的部分則以角色的象徵為造型，並以3D
建模的方式成型。

The map, with no fixed appearance, is formed randomly.
The advantage is that it gives each round different pleasure.
Chess pieces are designed according to the characters'
symbolisms, made by 3D modeling.

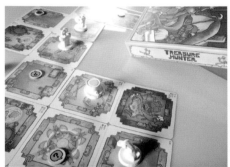
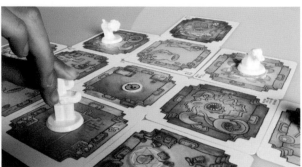

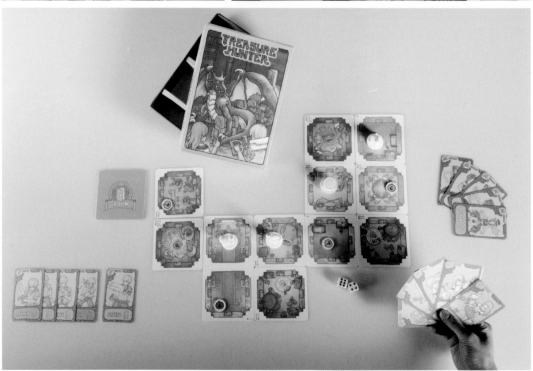

實際遊玩狀況 / Playing Time

帶上你的三五好友一起度過歡樂時光，成為奪寶獵人，在充滿寶藏和怪物的古堡中盡情探險吧！

Bring your friends together to have a good time, Be a treasure hunter, and enjoy the adventure in a castle full of treasures and monsters!

楊莉芸 / Li-Yun Yang

flickr.com/photos/vanilla2011
vanilla.since2011@gmail.com

寧可做有夢想的渺小平凡人，
也不願做一個偉大卻失去夢想的人。

I'd rather be a dreamer who is nobody,
than be somebody who has no dreams.

● 插畫設計 Illustration　　● 個人 Individual

插畫設計
/飛行夢

Q：專題介紹

A：我們沒有翅膀，所以總幻想著有一天能夠在天空中飛
翔。主角烏諾躺在草地上，看著雨後的天空顯得格外澄
淨，鄰居家的小孩也在草地上玩著一架模型飛機。模型
飛機從烏諾的眼前飛過，飛機飛上了天空，烏諾也開始
了她的幻想旅程。

Q：製作此作品用的軟體是什麼，它如何將你的設計發揮到
極致？

A：水彩技法與Adobe Photoshop CS5，透過手繪與電腦
反覆修改，達到自己想要呈現的樣子。

Q：請談談你如何克服創作上遇到的瓶頸，也給對設計有興
趣的讀者們一些建議？

A：暫時放下，觀看一部電影、打開一本書、開始進行一段
有意義的談話等。把自己從瓶頸中抽離，一段時間後再
回來看，也許會更明白該怎麼往下進行。

Q：可以簡述你的創作歷程與風格轉變嗎？

A：在「飛行夢」之前想了很多故事，也曾在劇情方面琢磨
了很多時間。從最初訂定的主題 "離家出走" 漸漸發展
出嚮往自由的夢。此期間會翻閱自己以前的作品，回想
起以往的兒時遊玩經驗，逐漸編寫出屬於自己的故事。

Q：你的作品有沒有很明確的脈絡，請問你都是用何種方式
來做作品？或者以何種方式汲取靈感？

A：大量翻閱繪本，從中選出一本想要的格式，搭配自己的
劇情描繪出來。掌握一篇故事的起承轉合，並將文字與
腦中浮現的畫面透過繪畫的方式呈現。

Illustration
/ Flying Dream

Q : Project introduction.

A : We don't have wings, but we always dream of flying
in the sky. Uno, the protagonist, lies on the grass,
looking at the bright sky after rain. The neighbor's
child is playing a toy plane on the grass as well. As
she watches the toy plane fly over her head, Uno
starts to imagine her dream journey.

Q : Which software did you use in this project? How
did it help you bring out the best of your design?

A : I used Watercolor painting and Adobe Photoshop
CS5 to complete my work. With hand-coloring and
computer work to modify repeatedly to achieve the
effect I desired.

Q : Please tell us how you overcame the difficulties
during the project and give some suggestions to
the readers who are interested in design.

A : Put it aside, watch a movie, read a book, or start a
meaningful conversation, etc. Distract yourself from
the problems for a while, then come back later, you
might have clearer ideas for next step.

Q : Could you describe the process of creating and the
change of style?

A : I thought of many stories before designing "Flying
Dream"; I also spent much time on plotting.
From the original theme "Leave Home," I slowly
developed a stronger and stronger yearning for
freedom. In the meantime, I would spend time
looking at my old works, recalling the experiences
I had in childhood. From this, gradually I wrote my
own stories.

Q : Does your work have a clear sequence of ideas?
What the method do you use for the work? Or how
do you gather inspiration?

A : Read lots of picture books, and choose a format I
want use to match with my story plot. Master the
transitions of a story, and present words and images
through painting.

畫面構成
/ Composition

構圖是在視覺藝術中常用的技巧和術語。特別是繪畫、平面設計與攝影中經常用到構圖這個字。一個好的構圖，可以將平凡的東西變得無與倫比、突出主題。

Composition is commonly used in the visual arts techniques and terminology, especially in painting, graphic design and photography. A good composition can make ordinary things become an incomparable and prominent theme.

構圖可說是安排與組合的經驗手法。將對比的東西分為主體與客體，或是前景與背景。將協調的物體用三角軸或是斜線來排列，將光與影變成有情感的組合，這些都是構圖的手法。立體派的構圖當中，以不同的透視點來安排物體，是典型的構圖風格。

Composition can be said to be the experience manipulation of arranging and combining. Divide the comparison items into subject and object, or foreground and background. Coordinate the items by arranging with Delta axis, or a slash, light and shadow into an emotional combination. These are all the methods of composition

繪製草圖
/ Sketchbook

從望遠鏡的視角去看地上世界。
Behold the world from the view of the binoculars.

表現高低、遠近等具有深度與延伸感的縱橫線構圖。

Performing the deep and extended sense the composition of vertical and horizontal lines (high and low, far and near).

與三角型構圖相反，雖有不安定的感受，但有動感表現的V字型構圖Y字型構圖、逆三角型構圖。

Although with a touch of instability, the V-shaped composition, Y-shaped composition and inverse triangular composition still deliver the dynamic performance, in contrary to the triangular composition.

● 插畫設計 Illustration ● 製作過程 Production Process

繪本介紹
/ Introduction of Picture Book

飛向天空　/　Flying into the Sky

海鷗也跟著她們一起飛翔，雲的那端是烏諾沒有到過的世界。在畫面的感覺上最有安定感，好似金字塔的三角型構圖，創造畫面的動向。

The seagulls are their accompanies. Over the clouds is a world that Uno has never been to. Like the pyramids, the triangular composition conveys the feeling of security in this picuture.

地上的人望著天空揮手，以天空中飛機視角看地上的人。

People are waving at the sky.
The picture takes the visual angle from the sky down to the ground.

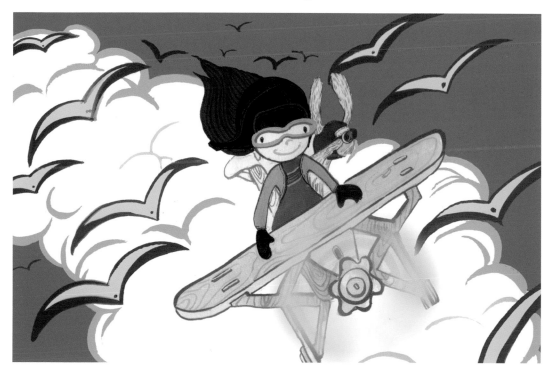

製作過程 Production Process　●　插畫設計 Illustration　●

降落 / Landing

飛機安全的降落，這是段美好的旅程。
The aircraft lands safe and sound. It is a wonderful trip.

星空 / The Starry Night

星星們連成了各式各樣的形狀，烏諾從來沒有看過這樣的星空。
The stars connect and form different shapes. Uno has never seen such a starry sky.

● 插畫設計 Illustration　　● 設計作品 Design Works

爬上飛機 / Climbing Up the Aircraft

「帶我一起走嘛！」烏諾説完，便跳上抓住了飛機。
飛機：「好呀！那抓緊囉！」
"Take me with you!" Uno jumps on the aircraft.
Aircraft: "Sure! Hold on tight then!"

展出內容
/ Content of Exhibition

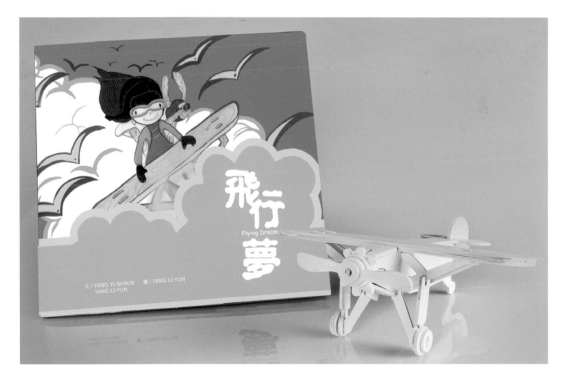

設計作品 Design Works ● 插畫設計 Illustration ●

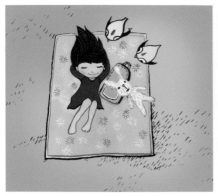

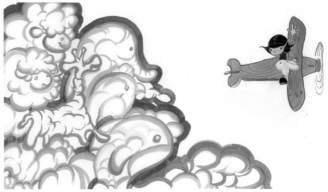

草地 / On the Grass

她們在草地上享受微風的吹拂。
They enjoy the breeze blowing through the lawn.

望遠鏡 / Binoculars

烏諾拿著望遠鏡遙望天空的另一端。
Uno looks into the distant sky with the binoculars.

告別 / Say Goodbye

烏諾揮別了她的動物朋友們，她很喜歡雲裡的世界，但她必須回家了。
Uno says goodbye to her animal friends. As much as Uno likes the world in the clouds, she has to go home.

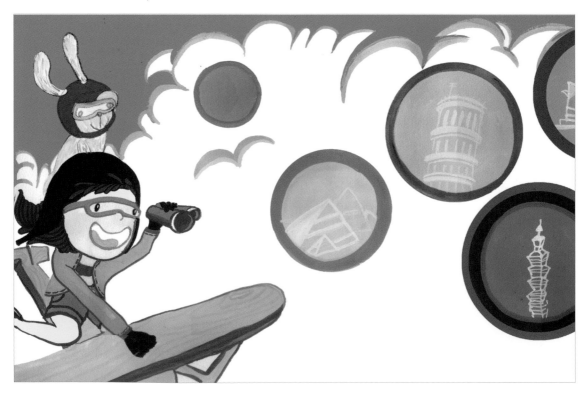

● 插畫設計 Illustration　　● 設計作品 Design Works

暴風雨 / Storm

大家都被吹散了。

Everyone is blown away.

模型飛機 / Aircraft

大家羨慕著旅行的飛機並且發出了讚嘆聲。我也好想像它一樣飛翔。

People gasp in admiration when seeing the flying aircraft.
How I want to soar in the sky as well.

設計作品 Design Works ● 插畫設計 Illustration ●

設計群 / Designers

張 鈞 堯　Chun-Yao Chang
楊 莉 芸　Li-Yun Yang
蕭 智 鴻　Zhi-Hong Xiao
呂 佳 懋　Chia-Mao Lu
張 德 美　De-Mei Zhang
施 漢 欣　Han-Hsin Shih
謝 　 雅　Han-Hsin Shih
徐 桂 雄　Guey-Seong Chee
張 清 媁　Ching-Wei Chang
張 勝 崴　Sheng-Wei Chan
鍾 馨 誼　Shin-Yi Chung

Class of 2012
Department of Visual Design
National Kaohsiung Normal University

國家圖書館出版品預行編目(CIP)資料

成為下一個設計師：設計實務流程解析 / 高雄師範大
　學視覺設計系第三屆畢業生作. -- 初版. -- 新北市：
　　新一代圖書, 2012.06
　　　面；　公分
　　ISBN 978-986-6142-25-3(平裝)

　1.視覺設計　2.作品集

　960　　　　　　　　　　　　　　101008245

成為下一個設計師 / 設計實務流程解析
Becoming Designers / Practical Procedures

總　編　輯：洪明宏
藝術顧問：林維俞　蔡頌德
作　　者：高雄師範大學視覺設計系　第三屆畢業生
形象規劃：紀　薇　陳威霖　陳羿希　陳逸芸　閻柏柔
美術編輯：閻柏柔
英文校稿：吳宛真

發　行　人：顏士傑
編輯顧問：林行健
資深顧問：陳寬祐
出　版　者：新一代圖書有限公司
地　　址：新北市中和區中正路906號3樓
郵政劃撥：50078231新一代圖書有限公司
電　　話：(02)2226-3121
傳　　真：(02)2226-3123
經　銷　商：北星文化事業有限公司
地　　址：新北市永和區中正路456號B1
電　　話：(02)2922-9000
傳　　真：(02)2922-9041
印　　刷：五洲彩色製版印刷股份有限公司

定　　價：新台幣360元整